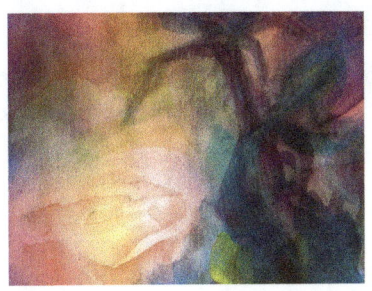

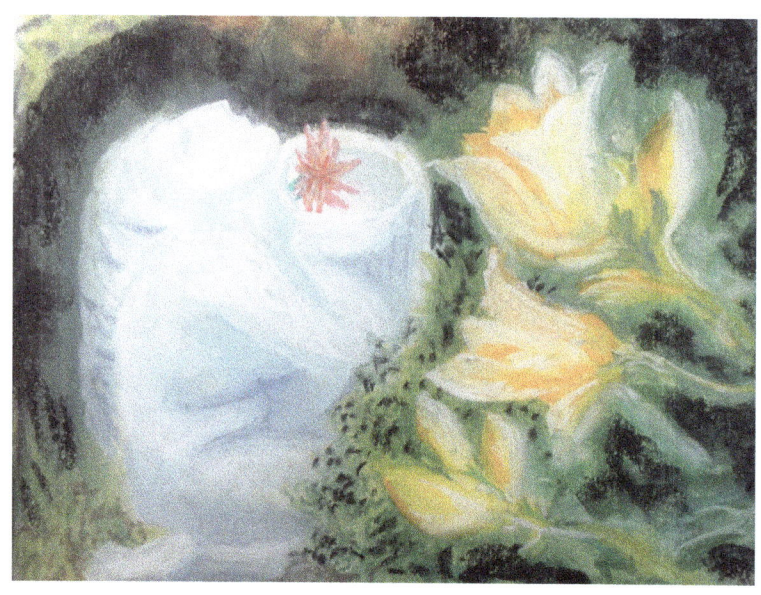

Dedication

To the memory of Harpo who created the gathering places - the Ebbtide Cafe and the Cafe Society - for "the love of good coffee conversation and jazz" and for letting the artists poets and musicians bring their arts into the cafes and the community of Half Moon Bay and the visitors that come their way.

To the memory of Marty who got us listening tapping and dancing on those Friday night jazz happenings.

To Thais who inspired me to create the Poetry and Pastel cards.

To Nick who was instrumental in the tech work needed for this book.

Poetry and Pastels
once upon a folded card

Rainer Neumann

Published by

landseandsky

Copyright © 2023 by Rainer Neumann

All rights reserved. No part of this book may be reproduced or transmitted in any form or by any means, electronic or mechanical, including photocopying, recording, or by any information storage and retrieval system, without permission in writing from the copyright owner.

ISBN 978-1-312-01920-1

Cover art is a pastel drawing by the author.
All interior art work - the poetry, pastel drawings and watercolors and photographs are also by the author.

This book is available through my storefront at:
lulu.com/spotlight/rneumann.
and media outlets.

Inquiries concerning the art work, poetry and cards by themselves or as "literature on a string" are also welcome at:
onhighwayone@gmail.com

Introduction

Last year some booklets of stories and art work were seen hanging in the home of Thais, a Brazilian woman who is married to my son Nicholas.

They were small booklets hanging on a string, a tradition well known in Brazil, coming from the poets and artists and story tellers in the countryside.

It is called *Literatura de Cordel* or *literature on a string* and they were brought to the market place to be read and purchased. Out of this idea I had a pastel drawing and a poem printed on one page, front and back and folded into a card. They became Poetry and Pastels and became a kind of calling card throughout the year.

Most of the poems were written during that year and the pastels were drawn over the last several years until 21 cards were created and offered to friends and the world…and since I was living near the coast I found driftwood pieces to attach a string to and hang the cards on. This resulted in cards hanging in my studio and also at the HMB Coffee Company as well as in a card stand at the Cafe Society in Half Moon Bay. It was encouraging and heartfelt to have many responses to the poetry and the images.

The 21st card was created for the winter Solstice in 2022 becoming a fitting ending for this endeavor, a journey of thoughts and words and art that chronicled the times and the seasons of the year.

For the book I have reproduced the pastel images and photos and a version of the poem or poems that were on the original cards. While some of the poems and also the pastels have been published in other books I hope their enclosure here will bring thoughtful meaning and inspiration to the reader.

Contents

Dedication. 2

Introduction 5

#1 Our Time has just Begun / Everyday We Rise 8

#2 Cafe Society / Let the Good Times Come 12

#3. Latin Rhythms / Livestream from Bogota 17

#4 the Flames 22

#5 the Hawk 26

#6 February / Love Song 33

#7 sit my friends 38

#8 a train whistle 43

#9 the Wild 48

#10 Wavering in the Wind 53

#11 Wings of Freedom 57

Contents

#12 Reaching for the Sky / On the Perch 62

#13. the Seeds 66

#14 Get on the Road 70

#15. America / ride the range rover 74

#16 Who Whoo hoo / Señor Sombrero 79

#17 To be all that we were meant to be 82

#18 Raul and Extensions of form / Thunder 87

#19 for Marty Williams / Birds Stop By 92

#20 Harpo "the Mensch" 96

#21 Every Year at this Time 100

Afterward 106

hopes and dreams 107

Other Works of Intention 108

Our Time Has just Begun
A Dream is in Our Eyes

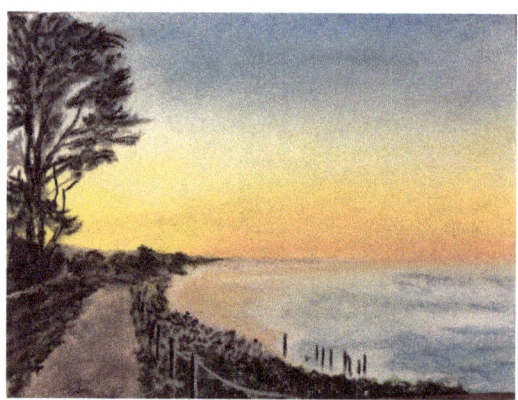

In the darkness of the season
Tragic acts come out of strife
As the sun sets in the evening
Casting shadows on our life
Now we wait within the silence
For the moon to shed some light
Our hearts will lead the way

We have seen the times a changing
And knocking on our doors
People of all cultures
Who we haven't seen before
Now we're dancing to the music
Of a thousand different drums
and the beat keeps living on

We have witnessed scenes of horror
And seen the pain they cause
Tragic acts of cowardice
That stopped and gave us pause
As nature has its forces
We must try to live our laws
Let reason be our guide

We have filled the cup of kindness
And passed it all around
We have seen the space between us
Become a common ground
We can find the strength to heal
and sing a joyful sound
our voices lead us on

In the sadness of the moment
I see some rays of light
It is in the eyes of children
Who have not come here to fight
their hands are in our trust
And open up our sight
their future lies with us

In the beauty of the morning
We can see the land so clear
We can see the dark disperse
and look at faces without fear
We have lived next door to strangers
And been taken by surprise
A dream is in our eyes

An age of change is now upon us
A fight for justice is before us
The search for truth will now restore us
Our time has just begun

Every Day We Rise

everyday we rise
we get up
we go on
in our somnambulant ways
to the bakery
to knead the dough
for the early worms
the fishermen of Half Moon Bay
 mostly but also fisherwomen
we go and bake
the raspberry danish for the morning locals
 and those taking in the sunrise views
we are the backbones of our communities
the underlying doing making fixing building and
landscaping of our communities...

everyday we rise
we get up
we go on
in our waking up way
 to the cafe
to drink our coffee
have a bagel with cream cheese
read the paper on a screen
get caught up on news or emails not yet seen
 call the construction crews
 and the landscape maintenance workers
 that have some pretty good reviews...
those who do the working and the transforming
and the maintaining of this our community
hearts hands and tools on the ground...

everyday we rise
we get up
we go on in our
almost ready to go way
to our places
to our meetings
into the extensions of our lives
the deliveries and the auto repairs
driving to the schools children anxious and eager
the day still to come to
enliven our homes wait for the neighbors
fences no hindrance
even if we are sometimes overwhelmed
by the tech revolution that is changing our world
the staggering connections of our lives...

everyday we rise
we get up
we take a shower
hot water fresh start
we go on in our ways
to open the cafes
even in a pandemic
the workers of Half Moon Bay
and all those who keep the legacy
give them credit
enjoy that omelet bite into that burrito
creations from our everyday artisans
who are working for the future
of these our communities every day
manifesting the dreams to be lived...

Cafe Society

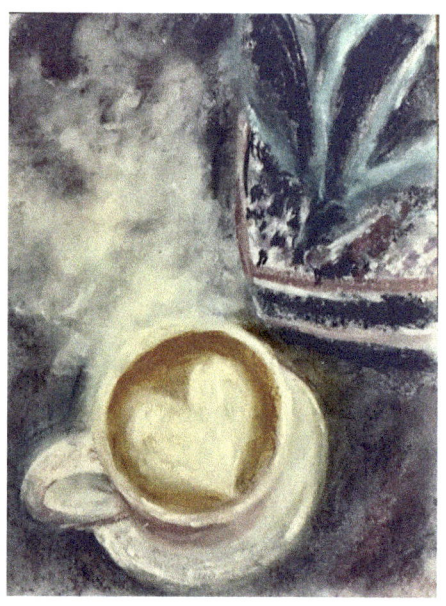

Friday after noon
At this cafe spot
Make shift space
Out of a parking lot

A piano player
Comes driving up
Takes a piano
Off a semi truck

Shadows creep in
The sun has gone
But the mood is mellow
Even with masks on

Jazz is happening
Mixing white and black
Easing discord
Bringing harmony back

Well you never know
Who might drop by
A wonder kind
Or just a gal or guy

They take the stage
Read some poetry
Words of concern
Thoughts of liberty

Well the wine is flowing
And the jazzz is cool
You found it here
A main street jewel

Yes even birds fly by
Tweeting the news
Rejoice rejoice
In the receding blues

Let the Good Times Come

they take their turns
around a melody
the bass keeps time
with piano keys

the sax man wails
occupies the room
lights up the crowd
like a full out moon

let the good times come
let the good times come
let the good times come
Let em happen soon

the drummer kicks
with his magic sticks
there's no retreat
when cultures meet

from a hollow log
to a shaman's fix
we're all a part
of a mythic mix

let the whole world come
let the whole world come
let the whole world come
Lets get our kicks

counter rhythms
and a solid beat
the wine is flowing
and the tea is sweet

the bass man plucks
those strung out strings
going deeper than
our discord brings

let the good times come
let the good times come
let the good times come
mend our broken wings

the sound is heard
up down the street
Harpo's cafe
is the place to meet

the piano player
now skips and climbs
bridging over
divisive time

let the good times come
let the good times come
let the good times come
and let them shine

she's on the mike
feeling the heat
her voice begins
down in her feet

the talking stops
the hearts respond
the time is like
the break of dawn

let the sweet bird sing
let the sweet bird sing
let the sweet bird sing
until the bells all ring

and let the good times come
let the good times come
let the good times come
with a beat and drum

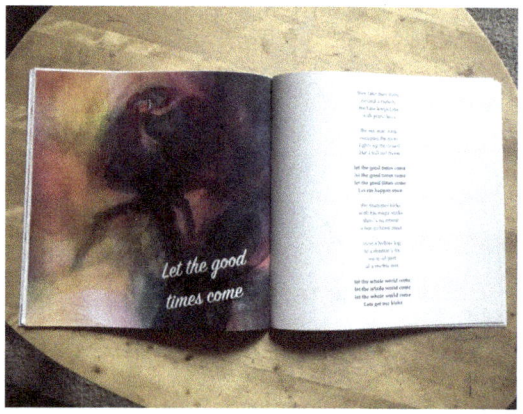

Lyrics from **"Friday Night Jazzz"**
by Rainer Neumann

Latin Rhythms

Latin rhythms
And a flute is blowing
High dee high and crowing
Place is ripe and overflowing
Word got out
No need to shout
Let the sound
Come around
That's what it's
all about
No need to question
No need to doubt

Latin rhythms
And a sax is wailing
High dee low and scaling
Place is up and hailing
Word got out
No need to shout
Fill the boat
Still afloat
That's what it's
all about
No need to question
No need to doubt

Bah da da da da da da
Oooh la la la la la la la la
Señorita so sweet
Bah da da da da da da
Oooh la la la la la la la
Hombre so suave

Latin rhythms
And a voice is crooning
Low dee soft and swooning
Mellow tuning
Word got out
No need to shout
Open the door
Let it pour
That's what t's
all about
No need to question
No need to doubt

Latin rhythms
And a Friday night treat
High dee high and sweet
When Brazil and the half moon meet
Word got out
No need to shout
Sway and play
Dance away
That's what it's
all about

No need to question
No need to doubt

Bah da da da da da da
Oooh la la la la la la la
Señorita so sweet

Bah da da da da da da
Oooh la la la la la la la la
Hombre so suave

Lyrics from **"Friday Night Jazzz"**

livestream from Bogota
living view from El Granada

static movement
in the remembered eye
rhythmic movement
of anticipation
tones floating
in the waiting ears
through the growing sprouting landscape
thriving in the spring of earth and sky
hills barely seen
in the mist of this rainy saturation
pampas grass now catching the ocean wind
a quick flutter back and forth
an overwhelming dracaena is also touched
it's yellow green leaves flirt and flicker
titillating the birds not yet interested
while a local finch is attracted
to the butterfly bush and the
hanging beaker of food being offered...

a sultry voice
in a soft inviting Spanish tongue
comes out of the screen propped up on the table
in the corridor of our outdoor threshold
her voice her words filling this intimate space
coming from some magical place in Bogota
live from a transformed living room in Bogota

one that the world has tuned onto and into
listening to the accompanying recorded sounds
of the DJ Bosque and the many gathered instruments
being played when the mood and the feeling
resonate in their transforming
of time and space…
oh the joy of the eucalyptus grove
playing swaying with the breezy blowing
of an ascending eastward wind
filled with long awaited rain
quenching the thirst of all
it touches and nurtures
after so many days of sunshine and
trembling waves upon the shore…
intentions rise out of the two figures dancing
in and out of the shadows into the light
of their instruments
into the rhythms selected and tones harmonized
creating a sound scape to play in to be in
the ethereal tones of a native American flute
saturating the air soothing us
eyes momentarily closing
letting the sound vibrate
through our bodies emanating outward
merging into all that is growing around us
we see the soft splatter of raindrops on the deck
and in the bird bath being filled
for tomorrow's resurgence
these transparent jewels of water
are holding and rolling
on the bright orange red passion flowers and
glistening among the leaves and tentacles
slowly overtaking the old wooden fence
that keeps no one in or out…

La May offers and intones a prayer
of beauty and reverence within the natural sounds
recorded and saved in some digital memory…

Gracias Gracias Gracias

her voice like a healing spirit fills the air
with words of solace and gratefulness and
momentary soothing in this time of such an
unknown and misunderstood invasive threat
here and for a short while, time has slowed
and filled us with the heart felt upwelling
of living vibrations strengthening our lives
helping us transform
the places we have come to
and the time we are in…

The Flames

stories told over the ages
around a fire place
once carefully built up in stones
the kindling the match
the flames
keeping us warm

now our city is burning
a hundred fires and more
near the home that we've lived in
the one holding our memories
our history our waking our prayers
our stories told at the table
in laughter and joy
a sudden burst and explosion
in fear and foreboding
moral awareness and human
connections broken
the flames
dying children

now our city is burning
a hundred fires or more
near the home that we built
out of savings and plans
our nooks our tiles our paint
our colors surrounding
the spaces we danced in

flickering conflagration
once contained once warming
only stones left standing
roof collapsed
in flames
the ashes smoldering

the fields they are burning
a hundred fires or more
near the home that we filled
with acts of affection
our photos our books our music
our stories told in the songs
we learned and sang

planned build up of arms
take over and killing
out of uniformed training
forgotten loved ones
the flames
ordered destruction
the trees are now burning
a few that we planted
for the shade that they gave us
from the warmth of the sun
our gatherings our friends
our time of reflection
drink and communion

our house is now burning
we've left it in time
on the road of the misbegotten
despondent refugees
home gone that grew with us
children were born there
once a room and a future
when will this horror
this invasion this circumstantial and
bloody rearranging of borders
become an awakening
recognized around the world
for all to hear and see
for all to bear witness
for the aggressors to be
held accountable
for the indifferent to act
for the leaders and those
who make the decisions to
realize the human toll exacted
the suffering of all those
just wanting to live and
fulfill their lives

when will our children lie
in a bed of comfort again
with the cross beams raised high
their rooms of sanctity rebuilt
with the age-old skills
of the masons and carpenters
after the dead have been buried
in graves of remembrance...

when will the unspoken pain and loss
become a story
to be told again
heard around the supper table
with loved ones still living
with a repast of paska and borscht
from the fields flourishing
in the seasons to come
from the seeds growing again...

the hawk
*a journey from an open deck through an open wound
and back again*

*afternoon stillness
hawk sits on a wavering branch
a mouse in the grass*

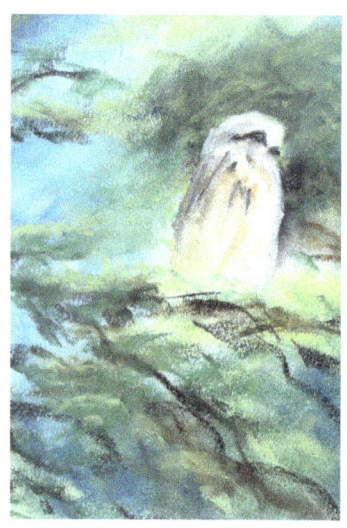

I'm out back
on deck
blue sky
so blue
passion flowers
so red orange
who is that
tweeting in the grandfather tree
a white crowned sparrow
waiting for an answer
in the left over wild behind our garden

a hawk is noticed
on a wavering branch
sitting looking into the stillness
surveying the grass the ground for any movement
daily hunger felt, the search is on
for a gopher eating the roots of the radish
the kale plant before its grown
aphids are on the leaves or are they?
bees on the blue rosemary flowers

a hawk is waiting
looking
another day
of being under
the contrails of a 747 super sonic jet
rising out of SFO
a engineered miracle still flying
in these times...

now comes the sound of a one-engined plane overhead
circling towards Half Moon Bay airport
just off the coast
runways are between Highway One and a bluff
with hilltop hiking trails and historic footprints
of the once thriving native people
and Portola's horses looking over
that waving splashing sparkling Pacific
so close to their "discovery" of what will be called
the San Francisco bay...

a hawk
with stern eyes
stern demeanor
furtive glances
bushy tan feathers
looking full fed
but still looking
while kamikaze humming birds buzz by
flittering and fluttering
all around it…
is this what it means
to be still
to be content
to be one with all one needs
to be in the moment
of a raptor's awareness

It seems I've just played with
the idea…
but an insistent tweet tweet tweet
keeps repeating like someone else
I've come to know
through the news and the videos
exacerbating the issues with
advisors rolling their eyes
and with a persistent disregard and
disrespect for those wanting some truth
and civilized response
somewhere near here
there is a softer response
a singing tweet has provoked a
bay bay bay bay of recognition
a possible meeting or another tryst

I hear a click of wings
an aggressive humming bird has taken over
and chased off a ruby red beauty
its long beak now entering a red plastic flower
the look up
the scorn of keep away
not so many years ago
John Muir heard the call of the
mountains again felt the mist of Yosemite falls
brought back the beauty and stories
to his valley home
infusing the curious minds and hearts to come
I am fortunate enough to
sit with a hawk
a wild distance away
no directive from the governor
just an understanding of
risk and distance and wild beauty

ahh but a fluttering yellow brown butterfly
has found the golden lilies
and joined our late afternoon happy hour
our sweet inhaling and imbibing twilight time

to have lived this long
to have opened my mind
to this wavering flowing
flying flapping fantastic sometimes
still very wild very still world
listen

I am overcome with
being alive
in such a moment
no internet needed
the GPS is not the territory

how do the hours
pass for a hawk
on a branch of green
quietly blinking and waiting
for the slightest movement
like my potential blank paper
waiting to be filled with ink
and remembered sunlight breaking
through darkening clouds
this hawk is hoping to see a meal
move in the grass and yes
we begin to get antsy too
even hungry fortunately
our meal is in the refrigerator
waiting to be fried

and still a hawk is there
and I have come closer
to stillness in its presence
like a quote from Ram Dass
"the quieter you become
the more you can hear"
like a moment of being in the world
and yet being in the constant
in between of knowing and not knowing

a strange state of mind...

that has arrived and affected my life
being in the now of a virulent virus
an unseen invasion attaching
itself to our breath of life
and also being in the throes of discontent
in the streets of masked faces batons and face shields
a flashpoint of injustice recognized

a knee pressing on the breath of life
videos viewed world wide
seen again and again stirring
a cauldron of protests and kneeling and commentary
under a sky of such blue clarity
and a field of green verdant life

strange paradoxes and ripening fruit
growing within the spirit of our times…

be here now
has become ironically real
we know the past
we are not sure of the future
we live in the risk and the momentary joy
of the present
sing it Jimmy
"the world is upside down
"the world is turning around"

a hawk is still there on a branch
no nesting in place
free to fly
free to be

I am
in the stillness
as free as I can be
in the world

within the buzzing clicking flitting of life
and the awareness and resilience and struggle
for change wary and wondering

and still watching
that humming bird syphoning
from the red plastic flower
filled with sugar water

I am
in the growing and being
of the waves of the earth
of the waves of the air

in the remembrance of the constant surf
and a primal world not too far from here…

Is the hawk still there? no…

the hawk has flown
the glass is empty
the sun is setting tis eventide
the heart beats on…

February

from Februus to Lupercalia to a Valentine to Hallmark

listening to all the different voices singing
their version of a Leonard Cohen song
the words still lighting the way with the
laid down chords infusing the worked over poetry...
can it be that somewhere
somehow in some aching of existence
a man with a "golden voice" has peered deeply
into the hearts of those who have loved and
sacrificed and wondered and listened...
who have heard the soft picking of the strings
and remembered the rhymes and felt the rhythms
aware of the references of the evolving meanings
the language expressing who and what
and how some of us have lived and become...

close your eyes and go deep into all
you are inside and all you are in the universe
while a violin draws the melancholic tones out of
their hiding place and the sleep of your forgetting
with the vibrations of our primal beginnings
and the on going back and forth upon the earth…
go now into your memories to those who
knew you who have heard you who have listened
and watched your heart expanding…

close your eyes and now feel the late
afternoon sun find a way to get
into your room through a window
not covered even as the day will end
and will leave you again…
so feel the warmth while you can
walk the loop through the
eucalyptus grove up onto the
hillside breathe deep turn and
look westward over the bluff
the descent of light has become
a glorious yellow orange red even as
the purple shadows grow…
hold on to this transcendent moment…
remember
it is us it is the earth
that is turning
so take one day and look at the calendar
the one with the image that lasts at least
for a designated month with the
ordered squares and current holidays noted

and look up the celebrations omitted
out of the ancient times of purification and the
naked running for fertility and much later
the martyrdom of one who became
Saint Valentine…

now write down your needed meetings
your rendezvous over the days
maybe a square of time with a lover
and one of Millie's long stemmed roses
or a time with that curious wide-eyed
four year old exploring together
or an hour of some music by a local
jazz group embellishing a love song
trying to "make it real"
hang on to all
and all those who deeply mean
something to you

and when you wake up to the light of another day
remember the choices and the freedoms you have
within a small area of place and time
in the field of your life...

and don't forget the love that can be
the love that is still free
the love for someone close to you and yes
for the ones gone but not forgotten...

Love Song

Well I've never sung a love song
Like I'm singing one now
Don't know where it came from
But it happened somehow
I've sung the old songs
Made up my own songs
But never sung a love song
Like I'm singing one now

And I want to be with you
Oh it feels good to say
I want to be with you
How long has it been
Since I've said it so freely
And felt it so deeply
Oh I want to be with you
To sing it again

Well I've never been so taken
Like I'm taken right now
Don't know how it happened
But it sure did somehow
I was contented
Single intended
Yet I've never been so taken
Like I'm taken right now

Well I've never had a lover
Like I'm having one now
Don't know where you came from
But you happened somehow
You are my romance
A crazy fast dance
The one and only lover
That's happening now

And I want to be with you
Oh it feels good to say
I want to be with you
How long has it been
Since I've said it so freely
And felt it so deeply
Oh I want to be with you
To sing it again

Oh I want to be with you
to sing it again

*A song written at the beginning of
many years and memories…*

sit my friends

sit my friends
speak from the mind
impeccable words
listen with the heart
of expansion
open yourself
this may be closest to
what it means to
begin to know

drink my friends
toast to the moments
of friendship
where trust lies
and judgement is
suspended
this may be the closest
we may come
to being free

don't forget the habits
of conformity are
unconsciously acted out
unwittingly responded to
unknowingly believed in
named out loud

sit my friends
find a place of stillness
somewhere inside
forgotten almost

forsaken
sometime ago
that may be the closest
we come to know
of solitude

drink my friends
let that cup of tea
warm your hands
let it penetrate
close your eyes
see the universe
this may be the closest
we come to know
of eternity

don't forget the maze
of enticements
coming out of impulse
coming out of wants
coming out of desires
never the same

sit my friends
we are almost there
we told our stories
touched on times gone by
some wrong turns
some acceptance
this may be the closest
that we may realize
our mortality

drink my friends
let that bouquet
fill your nostrils
swirl the deep purple
lift the glass
to your lips
this may be the closest
we come to a
miracle

don't forget the hearts
awakening
smiles come easy
a hand reaches out
closer so near
a first kiss

look up my friends
into the night sky
search for the patterns
of bright stars
Orion with his sword
the scales of Libra
this may be the closest
we will come
to astonishment

look out friends
the light casts shadows
of our potential
deep felt fears
invasions and conflicts
become nightmares
this may be the closest
we come to facing
our demons

don't forget the seasons
when plans were made
objectives met
work was done
fulfillment came
memories grew

sit my friends
we've wandered on
the floating water
of existence
born on the earth
breath of life
this may be the closest
we know of our
living essence

drink my friends
raise a glass to
all we've come to be
all we have created
all the arts and beauty
that surround us

this may be the closest
that we know
of beatitude

this may be the closest
that we know
of benevolence

this may be the closest
that we know
of love

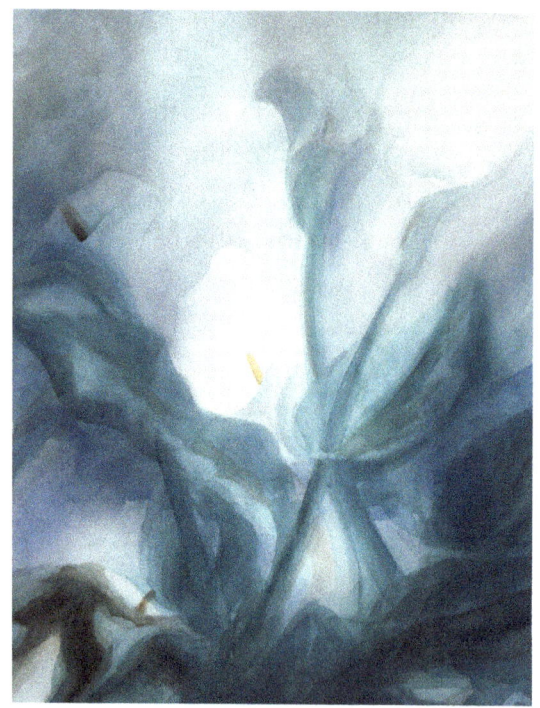

a train whistle

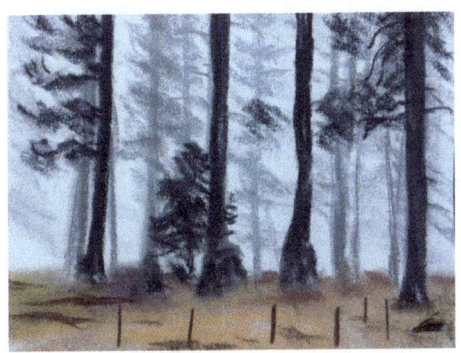

Life was simpler then
in innocence in trust
when I walked through the night
a seven year old on the road of flight
my mother pushing the carriage
my brother inside
I held on to the hand
of my father
no fear just walking
eyes almost closing
walking wondering...
Where were we going?
How much farther?
I could see the stars and
the moon gave us some light
I heard a train whistle blow
coming over the land...
coming around a farm house
between the bushes and trees
out of the shadows into me
I've been riding one ever since…

my mother had known fear
and struggle during the war
her strength was felt...
She had risked the gathering of wood
for warmth in the cruel winter of 45
and the hope of getting a few potatoes
from the surrounding farmers
in exchange for a knitted sweater...

We walked she pushed my
brother had no idea as we went
through the forest
away from the road until
a barrier a gate
a circumstantial border was seen
erected to keep ideologies separated
with living people and families
again and again becoming the victims...
We went around that barrier
and felt safe so glad to see
a different kind of guard
we were there we had made it
we walked into the freedom that mother father
had thought about and yet suddenly
it was with heavy hearts...
Would we find our father? we wondered
as we were taken to a guard house and
interrogated not allowed to go further and
cruelly told that we had to go back
that we were not allowed to go to the
American side of the divided Germany
out of abstract decisions made
regarding Russian east Germany
and American and British west Germany

fingers on maps deciding where the
new borders were to be who was to
govern and what rights people would have...
My mother cried all night
we fell asleep and in the morning
a guard took us back to the border
nothing we could do to persuade him
except that he unofficially said
go further down into the forest
where there are no guards...
My mother pushed the carriage
I walked slowly but intently
we trekked through the forest
no trail seen we stepped over branches and needles
we crossed what we thought was the
barbed wire of the border
and went further west
when west meant a heart felt freedom
for my parents and words for me
later becoming a land where we could
live a life with choices and opportunities...

Only later did I realize
the fear in my mother
the anxiety of my father
telling us to hide
that he would scout ahead
for Russian soldiers or
the local police at the border
he left us and my mother
worried waiting...
No return after so many hours
alternative plans remembered
travel on and meet in a

town called Hof just over the border

Further and further we walked until
houses were seen and a village
emerged and she saw the sign Hof
on a delicatessen
a chance to buy a roll
a feeling of such relief
indescribable for my mother
a story for me to remember...
But there was no father here
not found in the place we were to meet
in sadness and anxiousness
my mother bought tickets
at the train station for the next
meeting place a town called Langen

there was her hope and I must
have felt it with the excitement of
traveling on the train
even with no more money to buy
a roll or an apple
we finally arrived in Langen
walked to the address we had with us
an address from a relative
who had also left Zwickau...
We knocked on the door
waited and someone opened it...

Our father
who was so joyous
who held my brother tight
who held me forever
who held my mother in tears...

Here is where our lives began again
together...
Our lives now immersed in hope
and the dream to move to
America...

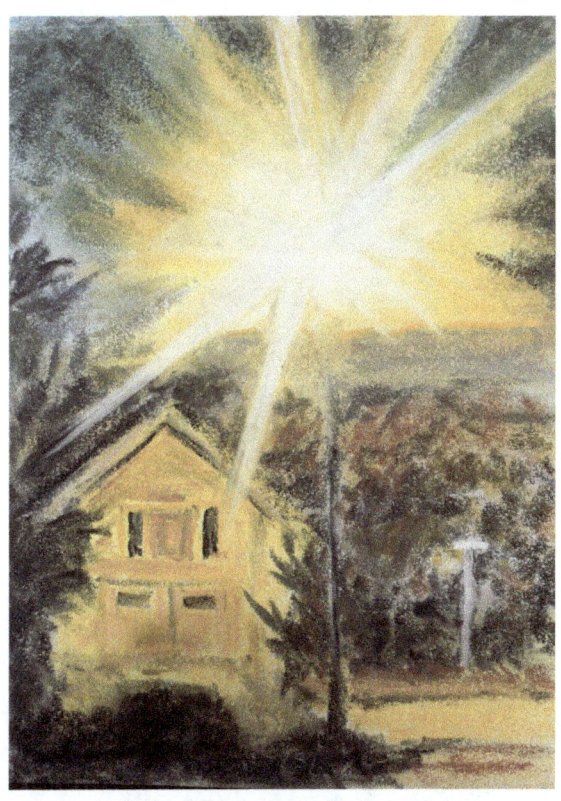

the wild

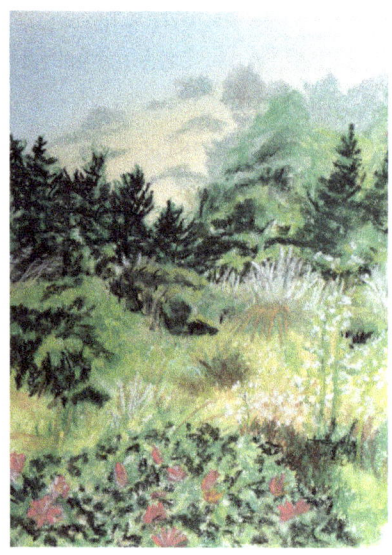

Sometimes we can feel deeply
and once in a while
and maybe many times
we can feel our heart expand
we can feel blessed
in age old ways
thankful to be alive
and living in the time
given to us…
This morning a gold finch perched
on a tree branch next door
its song sweetened the stillness
while a cooling bay breeze
let the branches sway in an uplifting sky

Something inside of me responds
to our long history
of evolving life

the earth still coming forth
being here now in all
its myriad colors and diversity
the grandeur and the wildness remembered
the interconnections
that are known to us
that resonate in us
that we have infused with meaning…

So many of us are fortunate
to have experienced the world
in its seasons and its mindful beauty
the transience of a sunset as the earth turns
yellow orange red fading into indigo…
while walking on sand and sinking waves
letting shadows take over and the night begin
letting dreams of wandering seep in…

being on a trail that takes me to Eagle Lake in the Sierras
along a stream that finally leaps and falls into Lake Tahoe…
climbing to the top of Mount Tamalpais in Marin County…
to overlook the flowing fog billow over the coastal hills
with an occasional opening into San Francisco Bay…
camping in Fish Lake Forest in southern Utah
and quietly following a path deer have made
throughout their daily foraging
coming to a light filled clearing
surrounded by a forest of firs and pines
soaring into the outlined sky
to sit quietly on a fallen log to see a five pointed stag
grazing in the eden of its world
to remember a vision experienced by a young man
wondering what to believe…

Quick now back home over the backyard banister
waking up to a sparrow's morning song
watching a white butterfly fluttering by
a humming bird sitting for a moment
with its wings attempting to be still listen
a buzz is heard by the white strawberry flowers
I pick a strawberry that has ripened overnight
feeling the succulence between my fingers
the sweetness of its taste

Next door the loud morning bark of their dog
lets the neighborhood know
he or she is watching and listening
a life born out of eons of human association
all captured in their back yard
the taming and breeding and training
and nuzzling and protection all next door
and so often they walk
their humans for some exercise
I feed him organic cookies
to make some kind of safe and quiet connection
(unfortunately not yet made but like moving into a new
neighborhood friendship takes time)

The clarity of the wavering coastal trees
overtakes my outward view the ancient cypress and
the relatively newly planted eucalyptus is astounding
foliage of all kinds setting the scene
the pampas grass the seasonal wild grasses
now poking up over our garden fence
all these living systems surrounding me
in such a clear focus with the accompaniment
of the squacks of crows and the songs
of unknown birds all under a soft blue sky
I answer with my own whistling twee twee tweeaaaa

Next door the sound of hammering and occasional laughter
fills the air doing maintenance when needed and remodeling
when structures need changes to adapt to
growing families (a bigger nest) or just a different
room arrangement (from the ideas and imagined
arrangements
of home improvement companies)

All these sights sounds and silences come
into my morning's contemplations wondering…
Has the earth no more far off wild for me? for us? and
the freedom all that encompasses?
Have all the demarcations of ownership been established
drawn on maps of countries and states and communities
with the occasional questioned borders being fought over?

This natural world we are surrounded by
still continues to find ways
to adapt and cross invisible borders just as people find ways to
leave what they have known and take incredible risks to cross
fences and rivers and guarded borders
in the hopes of adapting to a better life…

When will we realize the earth
has become our sustainable garden to be cared for
plowed and pruned and thinned and seeded and watered
and reaped and picked
for our lives to flourish beyond our hunger
in all its symbiotic and ecological ways…
Can we still feel deeply
going forward into the places
where the domestic and the developed and the
tame mingle with the wild outside of us and the
blood inside of us?

Can we still
wander close to the wild in our midst
and the places still preserved
letting our heart expand again
still feel blessed in age old ways
still grateful to be alive
thankful to be living in this age
still given a time to breathe
to walk the hills take in the in-between views
of the remaining wild and what we have tamed...

Can we still
wake up in this earthly garden
take a moment to sit and see a gold finch
perched on a tree branch next door
its song sweetening the stillness
while a cooling bay breeze
lets the branches sway in an uplifting sky

remember
what we have been born into…

Wavering in the Wind
(in the mourning of my thoughts)

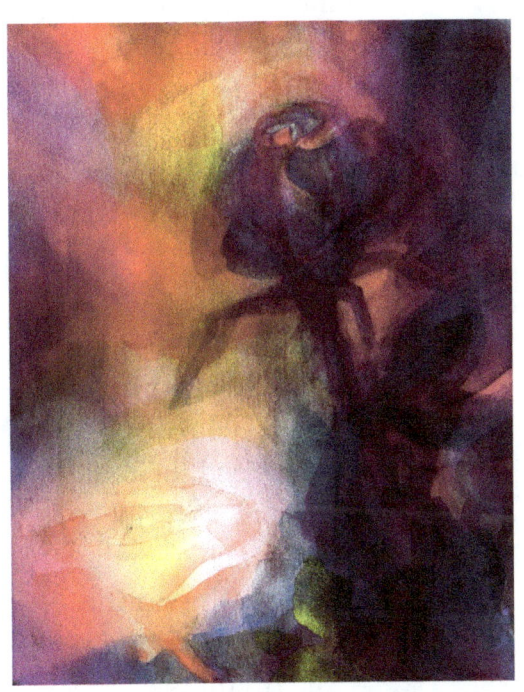

poetry and images
on a string
wavering in the wind
with the sounds of explosions
heard somewhere in the world
somewhere close a child's bed
a mother's fears a father's determination
to defend their home their land
within the circumstances
of their history...

untold generations living
through the seasons
fields of grain
gardens of beets
a mother's pain
the birth proclaimed
miracles of life growing
sustenance and beauty
the young men and women
becoming learning giving
working...

plowing the ground
in the spring
sowing the seeds of ages
becoming food to feed their families
and the larger world
harvest time the scythe
the muscles the storing
the songs the dancing
the rhythms...

old hearts filled with joy
sweet hearts finding their
secret place in a grove
childhood games remembered
now fingers on a soft cheek
lips touching
love found in the fallen leaves
the moon light consecrating their moment...

words also spoken
in love once read in the story of
Doctor Shivago in a time
of revolution and overthrow

healing the wounded and writing
of Laura in the snow and spring
someone said the words:
"no one loves a poet more
than the Russian people"...

Poetry and images
"blowing in the wind"
known around the world and again
the sounds of explosions are heard
and the roar of the tanks...
a horrendous undulating
mechanical snake slithering in on
the very roads of freedom...

somewhere on the screens
of the world somewhere nearby
a child is taken to the cellar
a mother's fears become real
a father with determination
and an anti tank missile on his shoulders
is risking his life for their future
while the sky is roaring and
indiscriminate bombs are falling again
homes once built are now shattered
and burning incinerating all within

the agony and suffering of
fragile living beings
now in circumstantial walking
lines of fear with children to carry
hoping to find some respite
a safer place somewhere
on the land of their ancestors
or somewhere next door
the misbegotten refugees

fleeing leaving their homes
seen on our screens
on the web of the world
the incredulity of some
Who decided this?
the misguided hubris
of those directing this
sending the young trained
youth to kill or die…

Poems and images
are hanging on my dining room wall
one from a trip to Odessa
only a few years ago a city
to walk in breathe in…
a drawing of lovers entwined
standing on a marble pedestal
a statue of lovers and love
now seen in their ancient beauty
rising out of flourishing life

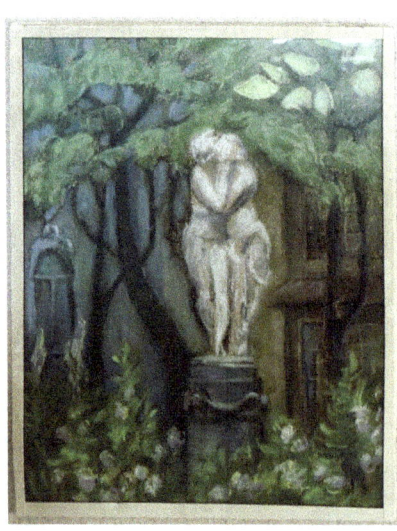

By a street artist from Odessa

Wings of Freedom

you can have your comforts
your cushioned chair
your jacuzzi too
you can have your daily
breakfast made to order
or you can make it
if you're so inclined
with Peets coffee in the grinder
press it like the French
you can sit out on the deck
in the coolness of an
overcast morning

hear the click
of a humming bird
(could it be Anna or Allen?)
see the white crowned
sparrow in the butterfly bush
hear the lapping of the dog next door
(quiet for a moment)
see the slight gentle movement
of the eucalyptus branches laced against
the white and light grey sky
an overcast remainder of the night

you can hear the fog horn blowing
the watch dog howling
unknown birds twittering and tweeting
their greeting to those near by
golden lilies are waking up
five yellow orange petals
opening like slow-mo
fire works bursting in July
look on the fence the overgrown
dense green leaves and tendrils are
punctuated with the ten pointed stars
of orange red passion flowers
celebrating their exuberance

I take in a wider higher view of
our natural cultivated varieties of greenery
interspersed with the waving flickering
beige pampas grass on slender stocks
catching a slight breeze coming from the bay

and moving up the hillside I imagine
a medieval castle built on its outlined crest with
overlooking embrasures and pointed spears
a legacy of defense from another time and place…
now the mist shape shifts and becomes
a group of native inhabitants
camped between the coastal trees
this land infused with the spirits
of many generations
still remembering another time…

look closer now
just off the deck
small white flowers between
the red wood chips are blooming
strawberries ripening
hiding amidst the shaded
green glistening leaves
ahh sweetness consummated

I have fed the birds
filled the plastic red flower feeder
thrown organic cookies
to the growling barking dog next door
now a few drops fall into the
flittering fluttering slow moving
swaying growing blossoming world in my sight

quick under the umbrella its coffee and
with this elixir in my cupped hands
I live into the rain falling dropping
splashing on the leaves the branches around me

soaking into the dry soil seeping down
feeding the roots going deep
feeding the seeds opening reaching for the sun
words sprouting thoughts on the run
while two far off eagles have come gliding
out of the far reaches of the covering clouds
in and out in front of the hillside
the magnificence of such floating flying
wings of freedom…

I was once a young man
remembering my 13th birthday
stepping off a Greyhound bus
with no gravity holding me down
with thoughts of roaming and exploring
within a land that felt like freedom
with no fences that I couldn't climb
raising my hands to the sky
reaching flying…
grasping what I could
and
what was to come…

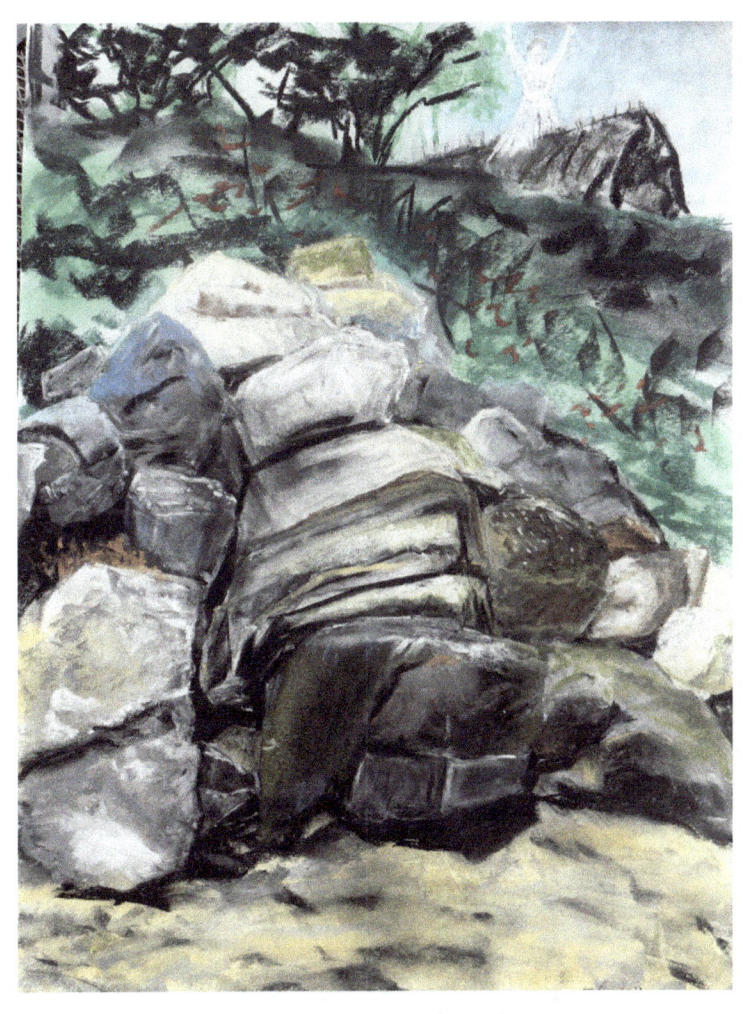

Reaching for the sky
an ode to mountain joy

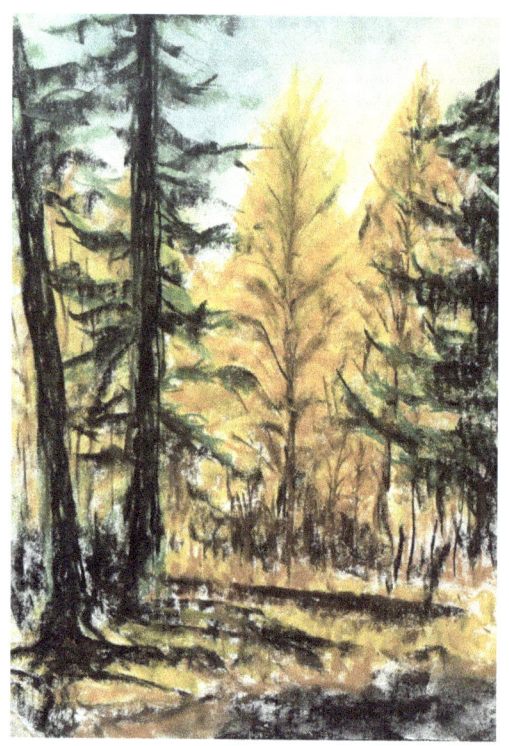

now
sitting here in made up comfort
perched upon the wooded hillside
watching and listening
I have become part of a consecrated mountain symphony
resting and rushing through its movements
on the edge of a designated wilderness and the
hum of traffic on highway 89 curving around Lake Tahoe
witness to nearby Emerald Bay and the Vikingsholm

all under this blue dome of a cloudless sky
a flittering of light and shade opens the first movement
the aspen leaves begin their quick staccato shaking and quaking
while a stately pine in shadowed repose waits for its moment
to bring in a graceful slow swaying underlying theme
as the wind blows from the mountain height affecting
all the growing instruments in their flexing and bowing and
solidity
the manzanitas slightly tremble
a buzzing fly flits in and out
a high treble tweet a blue jay's squack
while the out crops of granite move very slowly
in the eons of time
now
and then silence enters and a great stillness is felt
and again a great shifting and blowing of the wind returns
like Beethoven's never ending endings
until we are filled and spent and ready
to contribute some of our own movements
some of our own staggering ideas and grand notions

to this mountain setting
something we deeply feel
something needing to be done someone wanting to be loved
some unchangeable tragic experience
a reality to be carried and worn as only we can
as only we are capable of bearing
in our acceptance
in our overcoming
in our chorus of never endings
in the becoming
of our lives

on the perch
a Sierra hillside

on the perch
looking into the
descending light
day is almost done
will tomorrow find us mending our wounds

a wind whooshes in
breaks off the dry
dying pine needles
the branches wave
the aspens flutter and dance in the twilight

on the perch
feeling the cool air
finally we breathe
smoke is almost gone
fire has spared this rustic home once again

a wind blows into
this Spring Creek valley
pine sentinels spread a
a carpet of needles
a yearly season is beginning to turn

on the perch
thinking now of covid
and random fires yet
finally we come together
feasting on our friendship and times to come

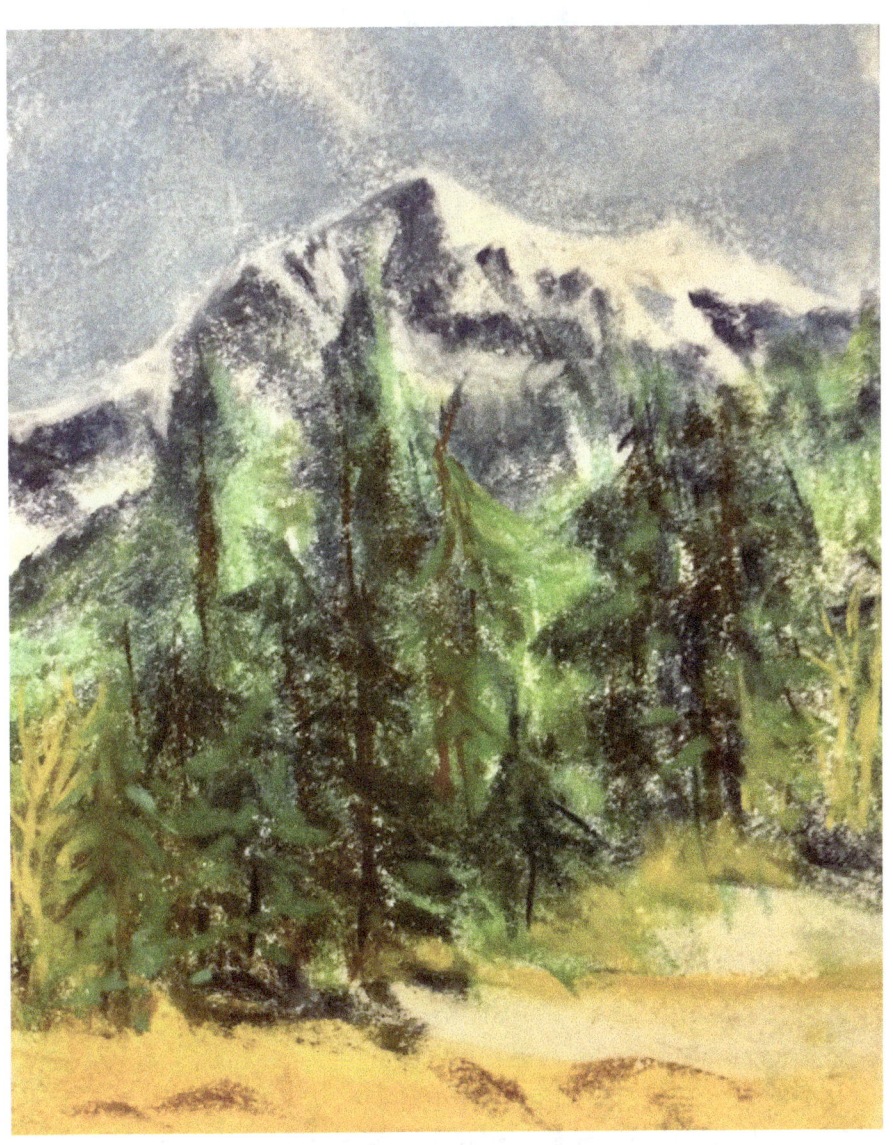

the Seeds

the seeds of my ancestors
on one pine cone
found amongst many
yet here it is dangling in a framed proscenium
constructed of found branches and tied to the deck
of a cabin in the mountain basin of Lake Tahoe
one spray painted pine cone waving gently
from Mount Tallac's breath like greeting
coming from its craggy granite face
the valley shakes
the aspens quiver
the ponderosa's like
the touch
one pine cone
with uncounted seeds
gently swaying in a threshold frame through which
a hillside of rocks and fallen branches can be seen
a variety of props with a chorus of pines and firs
reaching upward sprouting spring green needles
with small young pines growing close to the ground

not waiting for Christmas presents while
evening rays of light move over these sentinels
throwing dappled shadows onto
the soft layered paths of anticipation

like the king's men at the Globe theatre
the broken branches and porous stumps and dried needles
are waiting out their moment
on this stage waiting out the winter's curtain
to open to their stories of sacrifice
their tragic breaking and falling
and their glorious reaching for the sky

how many seeds are on one pine cone?
do they all know their lines?
how many seeds would have found a
place in the fertile ground?
yet somehow you were chosen and picked
out of so many that had fallen and now
they are recognized with star billing...

who was your designer
what script did you follow and
how did you grow into your role
for this theater season
look closer now
there is a pattern to your
spiraling flow of seeds...
what inner growing pattern
did you follow and
were you worried that your
furry and more mobile hungry
friends would eat you one seed at a time?
maybe leaving some to bury down
to find your mother again
to continue to start all over again

the light is streaming through the trees
revealing all the living and dying
exposing the rough and jagged bark of the giants
letting us see the dead branches and the ever growth
of deep green needles
now I am looking up the hillside
we can hear the birds and
the wind and I can remember
a clear baritone voice singing
"I'd rather be a forest than a street
yes I would if I only could…" if I only could…
a folk song coming from the Andes
into the Sierras into this hillside grove
within my lifetime
after so many years…

then by happen stance
looking through the framed threshold
with the dangling pine cone of beginnings
twisting and turning there is
a spotlight illuminating a huge white
fallen dying tree way up on the hillside
I look through the frame and up
this living canopy of tree lined growth
seeing a spot light focus on
something moving something
now seen and moving
a large dark brown bear
rising up and over the white trunk
over the top into the scenic spotlight
the rarely seen yet anticipated star has arrived
there is commotion names are called
look wow hearts stop this weighty Orson Wells
has come out of the natural wild
out of the all encompassing side curtains
of natures work…

we are mesmerized
this fat fury awesome cameo moment has become
the ebb and flow of a mythic story unfolding
in our time
the moment has come and is happening here
we look watch while its claws are ripping
the dying trunk apart looking
for the tragic critters inside
the ones living and now being sacrificed
not questioning their part their death
once relishing the composting wood
they are now in an age old cycle of
transformation and becoming
in the unending last scene on the stage
finally we see the mythic beast leave the light
go further back into the shadows
we are feeling its eyes on us
the audience of onlookers
standing room only no tickets needed...

yes we were there we were a part
of this primal moment and were entranced
coming to the closest of forever
and the nearest to living
and being and communing
with the wild

Get on the Road

I need to get on the road
I need to meet the forsaken again
the ones who left some place
lost something they've almost forgotten
left someone behind a marriage a touch
the children of love or a moment's desire

how strange that I could live
in my loneliness and listen
to the words of a singer
who says it so well
who can open the heart
to feelings barely remembered
who can find and bring out lost words and
embrace me in a life time ago
yes I know the famous songs

the ones that go deep
that so many have felt
the ones residing in our collective memories
the ones that can enter into our world
of loss and sadness and indifference
the songs that so many have sung
and played and accompanied in their way and
somehow were able to bring into the music halls
and concerts of our shared communities
and now the internet of our connected lives
so many heart aching words and
foot steppings of the beat and
hand strumming of the strings

how strange or really how miraculous
that I could be in a lonesome moment
filled with the language
of a kindred soul
of a poetic mind
listening to the stories that the troubadours and
folk singers once wrung out of their hearts
recalling "a long black veil" or a mother questioning
"Where are you going, lord Randall my son…"
songs of the ages being rewritten and sung
in the coffee houses the cafe Wa and Gerdes and more

listening to the music of a restless generation
that went into the streets the parks the happenings
emerging out of the well spring of youth and concern
looking for an America in the midst of its shortcomings
and its heady ideals and sought after dreams…

and now I view the found films and the videos
that have become so much of my sometimes solitary
left over late night time…

the sacrifice of "Joan of Arc" by Leonard Cohen
"Farewell Angelina" in surreal imagery by mister Dylan
the bittersweet singing of Kris and Rita
viewed again and again
with their voices aching
their eyes searching peering deeply
"lay your head upon my pillow
hold your warm and tender body
close to mine and make believe
you love me one more time…"
love found in the midst of cultural upheaval…

how overwhelming at times
when the floodgates were opened
when words and songs gave voices
to a revolution of sorts
challenging the status quo
marching for freedom
the kind of freedoms not yet recognized

"Some thing is happening here"
was heard and danced to smoked to
marched to and the word became
"love" your brothers and sisters…
until the dialectic
of history intervened…

like the crossing of the Delaware
without canoes in sight
the storming of the Bastille
before the guillotine

the world protesting
the body bags of young men
coming out of the jungle
while two fingered peace signs

were seen through car windows
with a march onto the capitol to
right the incessant wrongs
of a segregated society purporting
to have equality of opportunity
"We shall overcome" was sung
overlooking the Washington obelisk...

I need to get on the road again
listen to some of those oldies
put some miles between those times
and where I'm going and where we are going...
put some new sounds through
the speakers to feel that bass and
the voices that are emerging around us...

let me go deep into the heart and view the vistas
let the new sounds come in now
all the beats being made and the
words being sung that have been recorded
and played by the DJs and streamed into
our connected world let them all surround me
all the singers and writers and poets
and artists and let "love" still be
more than a "four letter word" embraced
and sung and lived within a new generation...

America
our future legacy

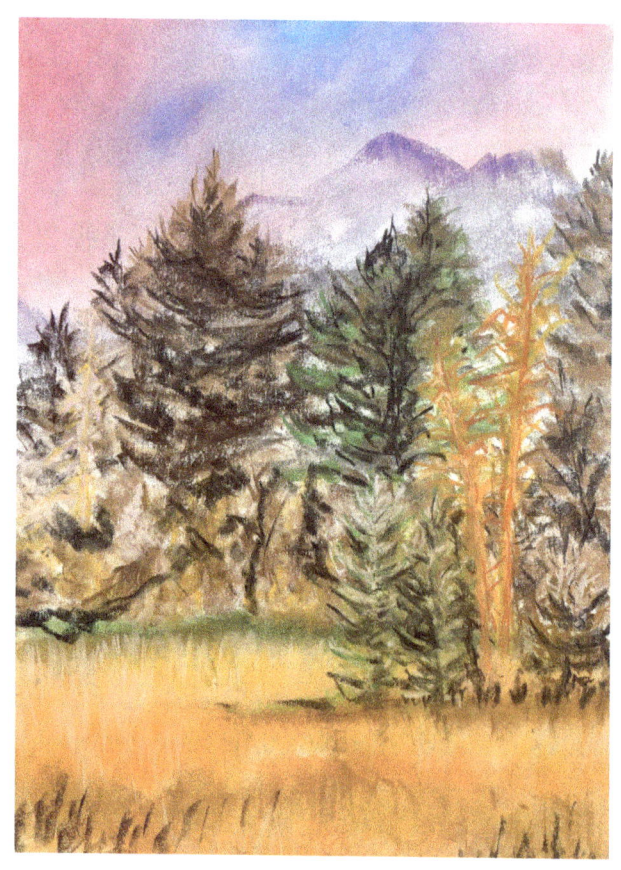

You're found on the fortunes of kingdoms past
A destiny riding on a land so vast
Where the Hudson flowed
And the geese flew high
All the world took a hold of you
Like a ancient prophesy
You seized the time
And it came to pass

You're found on the fortunes of native blood
A destiny riding on a shaman's faith
Where the spirits dwell
And the eagle's soar
All the earth was sacred then
And lived in stories told
You seized the time
And it came to pass

You're found on the ownership of human slaves
A destiny riding on the lash and chain
Where the cotton grew
And a war was fought
All the world has lived with this
A history to be taught
You seized the time
And it came to pass

You're found on the fortunes of sweat and steel
A destiny riding on the turn of a wheel
Where the fires burned
And the forests fell
All the world took a part of you
And the gold that could be found
You seized the time
And it came to pass

You're found on the fortunes of a hopeful smile
A destiny riding on the wings of a dream
Where seeds were sown
And chances grew
All the world has come to you
For all you promised to do
You seized the time
And it came to pass

You're found on the fortunes of human rights
A history of struggle and courageous acts
Where knowledge grew
Free speech upheld
All the world looked up to you
And the freedoms you fought for
You seized the time
And it came to pass

You're found on the fortunes of a planet's turn
A destiny riding on a valiant search
Can you turn the tide
Of a desperate course
All the world is with you now
In a web of fragile hope
You seized the time
Will it came to pass

America
you fought hard
and gave all you could
now you're stained and scarred
and your wounds reveal
the world in doubt
the lives left out
discord has broken
the common wheel

America
you fought hard
and gave all you could
now you've got to rise

and let your spirit shine
on our diversity
our future legacy
to quell the fears
of uncertainty

America
You seized the time
Will it
Come to pass

ride the range rover

come on
ride the range rover
there's plenty of space
plenty of time
the vistas are wide
led by desire
to rise with potential and what may become
there's so much to be done
there's still more to be done
still dreams to realize

and suddenly the sky is on fire
look into the west

the faithful streaming of our star has left
yellow orange red above the horizon
let us remember and let us breathe in
the coming night...
this is what we've come to know about
the turning of the earth
the transient moments we have been given...

there's no use in wanting to be
somewhere else in the world
existence as we've known it is here
even as it remains in some akashic memory stick
or cloud expanding outward in the universe
it comes from our place our home here
the living memories we have created in such
a short time the life force we still feel
the living experience that we have become..
while the white caps in the distance are
rising out of the sea breaking and flowing
in patterns never to be again just to sink
into the beach the strand of all constant change
this is the footing and the base on which I stand
the footprints I leave the castles I build...

Who whoo hoo

Who whoo hoo
Who whoo hoo
Who whoo hoo
the dove sings in the morning
I look around for the softness of its being
on the wire
on the roof top
I barely see it rise and fly
into the overcast sky of forgotten dreams

Who whoo knows
Who whoo knows
Who whoo knows
the heart wandering in the pain
I think of the misguided minds in the news
of their invasion
of their shootings
I conjure up the courage
to resist despair and live into another day

Who whoo wants
Who whoo wants
who whoo wants
the desire rises in the darkness
I reach around for some warmth and touch
that can soothe
that can fill the loss
I barely keep my balance
standing in the shadow of a doorway

Who whoo sees
Who whoo sees
who whoo sees
the patterns of our living world
I look for them in abstract accumulations
of a billion choices
too many hungry
while someone video tapes the happenings
and documentaries attempt to enlighten

Who whoo feels
Who whoo feels
Who whoo feels
the love beyond our needs and desires
I look into the faces of people around me
life engraved
life in wonder
such a short time on this orbiting planet
daily acts and miracles still coming forth

Señor Sombrero
on the pier in Sapzurro, Columbia

Señor Sombrero
no cantraro
sits in the midst of
compadres so true
life is good here
no one to fear

a place of beauty
a paradiso oh oh oh oh oh

Señor Sombrero
no contraro
sits in the midst of
children and love
like waves and the sea
so full and so free

a place of beauty
a paradiso oh oh oh oh oh

Señor Sombrero
no contraro
sits in the midst of
a garden so lush
fruita and fisha
makes his life richa

a place of beauty
a paradiso oh oh oh oh oh
Señor Sombrero

To be all that we were meant to be

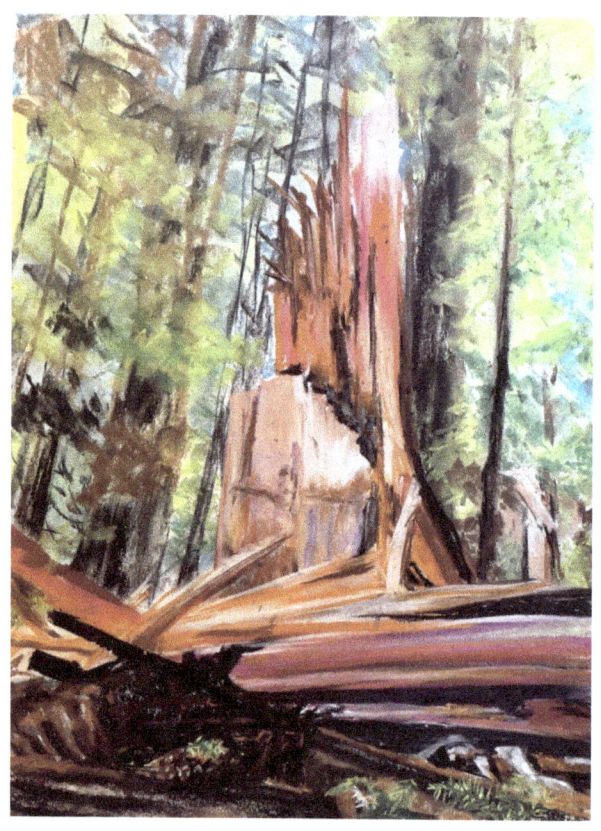

I've walked through the Ishtar gate of Babylon
It's blue tiles scattered over the centuries
Brought in boxes and pieces
An ancient puzzle
Meticulously restored
In the Pergamon museum of Berlin…

I've read the chronicles of Dylan
Remembered the streets of the village
The poets in Washington Square

Music coming out of Bleeker Street
Every door sounding out
A poet singer finding his voice
In the Cafe Wha
And the word spread
Over the land that was yours and ours
To the young hearts beating
To a new generation
In anticipation and waking
Up to suburban stagnation and missile conflagration
Facing east looking west...

I've seen the paintings of Caspar David Friedrich
His romantic views of broken down cloisters and
hazy spiritual remains
And two men contemplating the moon
Before it became dusty with footprints
Leaving a black frocked wanderer on the mountain top
Overlooking the valley below
Covered in mist and clouds
Hiding a future of unspeakable horrors
Known to future generations...
I've read the elegies of Rilke
And thought about his angel
That we could never become
A state of striving reaching grasping
Without a savior without redemption
Without imagined kingdoms in the heavens
Only to return to the source
Of his words the beginnings
Of his creations...

I saw the learned despondent scholar Faust
Sitting among his many books of ancient lore
The hopes of earthly satisfaction
And final achievement
Only to find frustration and wondering
If life will ever offer contentment
Now reaching for an elixir of the mind
His longing open and revealed
Ready to forego his soul his immortality
To be signed away in blood
Only to unknowingly set tragedy in motion
Only to search further into the past
The ideal beauty of Helen
The reclamation of land
Only to unknowingly set tragedy on fire
Yet through all this and more
He found redemption
In a higher love…

I've heard him speak I saw his forms
Bucky's final thoughts his words
On the critical path that we are on
Fueled by the necessities of living
The daily struggles for water and food
The basics of our lives
The hollow eyes of a child
The extended belly
The empty container upon a women's head
We must go on he said utilize our resources
To meet the needs of all humanity
We must go "from weaponry to livingry"
He said to those wanting to know
How and what to do we must realize
Our underlying connections to the living world

But too many engineers scientists senators
Legislators oligarchs warlords authoritarians
And circumstantial power players
Did not read his books or attend his lectures…

I've seen the news and read the commentary
Mz liberty is cracking the torch is going out
The razing of values in broken neighborhoods
Cities and states of living
The lines drawn on the web of the world
Spite and hatred and division spilling out
Of the great struggle of who we are
Who I am in relation to all we are
In this place and time of existence

Infused with the highest historical ideals
With such a tragic and sometimes horrific past
That still embroils us today
Yet history is still being made
By all who value our freedoms
Now shining on hand held screens
These torches of immediacy and connection
Shining their light on hard found truth
And welcoming inclusion…

I felt the blood surge
Through the young man Parsifal
In his glory the fulness of his muscles
And his veracity the potential of his love
I met him on the path
In the midst of the age old woods
In the soft clearing within the towering
grandeur of nature's works
Still innocent of wrong doing
Still wondering and questioning

Open to the great needs of the earth
The storms the floods the heat
The arid dryness of defeat
Felt by so many desperately
Looking for the path and passage that alleviates
The wanton destruction of living systems
Through want and desire
Through greed and desperation
Through hunger and thirst or
A late night run for a fix
That would bring some relief some forgetting
From this open wound
Until in innocence he asked:
"What ails thee brother sister
Are we not the conscience of the earth?"
With that question a silence resonated
In the byways and soundways of the world and
Human hearts felt their primal beating
Within the trembling of the spheres
And the aching of the earth
Until our star our sun came streaming
Into the morning of our awakening
Invigorating the life force in ourselves
To rise and act and give back to our living source…

It was then that the wound began to heal…

Raul

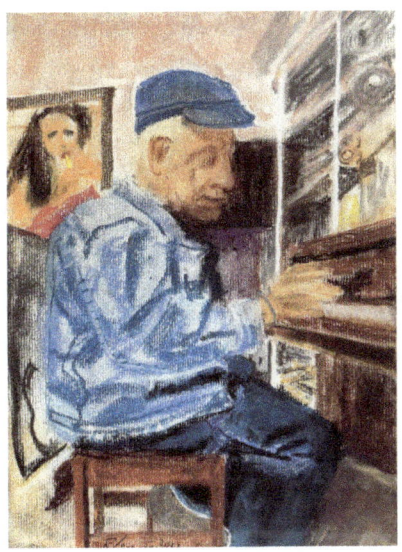

the tinkling of the keys
young ears grabbed chairs
around you and the piano
I think they said "Maestro'

dear man and mensch
a lifetime of concern
and artistic expression
from Paris to Oaxaca

you took me in for a
few days an extra bed
in your studio waking up
to see you working in

overalls a huge brush
in your hand the canvas
gave in to your vigorous
strokes to bring two
ravens to life

the morning sun saw you
doing Tai Chi in your
courtyard and I saw you
drawing an eagle and snake
for breakfast Mexico
remembered on that napkin

just as the world will
remember your many
images of protesting times
the tragedy and recognition

and I will remember being
within your landscapes
of living and flying birds
of freedom…

I will also call you Lieber Meister
on this day in this moment
of your life…

and the extension of form

almost lost myself
today wondering
what would emerge out of a
once upon an afternoon
with this artist of Oaxaca
walking to his weekly model drawing class
I followed him into Paris of the 20's many
artists were poised with pencil brush and paper
waiting for the young woman to take off her
robe of modesty and pose for a time in the
nude moving too fast I thought slow down but
this was to loosen up the hands and arms slow
down let my eyes settle on your body your
beauty of form and softness with a stroke of a
pastel sinuous again now flowing round about
the breast the hips the legs folded back the
extensions of eyes and mind and hand holding
a medium of some lasting value of seeing
and doing and capturing…

yes
a lovely female body and wondering mind
now still for a while what are you thinking
as you look out the window?
could it be the love you left at home
or a north light garrett in Paris or the
joy of being held in the movement and
stillness of beauty or the age old reminder
of drawings on cave walls or the possibility
of buying a baguette and cheese on the way
home….

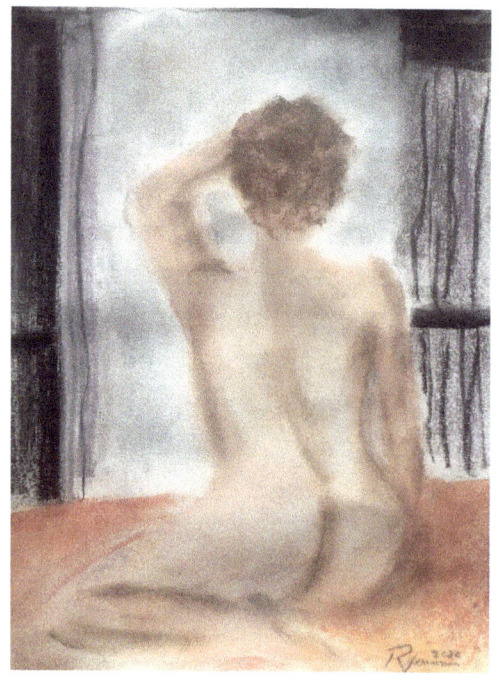

Thunder

Thunder like I've rarely heard
right above our humble rooftop
the reverberations of the gods of many cultures…
A light pattering of rain drops
is sent in appeasement
and a momentary brightness
strikes in abeyance…
My covers are the warmth
of illusion of security
I am at your mercy
oh atmosphere
so felt within the turning
of the earth…
This is our movement in time
and yet so momentarily startling
in the darkness…
What matters?
What has substance?
What great stonework could remain in place
if just one bolt of lightning found it?
Found you or me…
I am in awe…
To sleep perchance with a soft tear…
circumstance felt in the closing of my eyes
until the sound of your breathing
lets me join you
in our rhythms and
sleep of forgetfulness…

for **Marty Williams**
in his memory

suave Marty Williams
your presence felt when you graced the door
before you sat
and took your place
we felt something was going to happen
how would you start what notes of action
usually a few gentle thoughtful sounds
let the crowd listen and come around

cool Marty Williams
got to know you behind the piano
touching keys a few tones
becoming a remembered melody

then a brush eased in with an easy beat
the bass adding a constant repeat
finally the mellow tones of that guitar

savvy Marty Williams
watched you listening making eye connection
just a nod a responce
becoming a knowing solo direction
each instrument taking a spotlight moment
to rif and play into that unknown place
and bring the scene into a hallowed space

aching Marty William
voice in pain singing of his loving wife
words written chords felt
with enough heartache to last a life
yet here he was playing through
song after song and tapping the floor
"don't worry" was sung by us and more

engaging Marty Williams
time was on hold
when he came to play
Friday nights Cafe Society
picking keys with his usual propriety

we clapped some danced into the night
the atmosphere was charged alright
he made it real

no one compared to him

Birds Stop By

*inspired by an evening of
jazzy sounds by Marty and band*

you and I
can't go by
we're flying high
on Main Street
upbeat sigh ain't no lie
birds stop by
at this Bay beat

on Friday night they're all plucking keys
filling space with their harmonies
breaking free of all the vagaries
going deep into those memories

let's take a break from the daily news
the acrimonious sour views
a place to blow away our downward blues
you know damn well we've paid our dues

buh buh bah ba ba ba ba bah

you and I
can't go by
we're flying high
on Main Street
upbeat sigh
ain't no lie
birds stop by
at this Bay beat

that east side village has nothing on this
way back sounds that do not miss
brought out here with a soulful kiss
to bring us into a state of bliss
well the saxophone's blowing out the door
a hundred toes tapping on the floor
everyone here really knows the score
they're all up jumping and wanting more

buh buh bah ba ba ba ba bah

you and I
can't go by
we're flying high
on Main Street
upbeat sigh
ain't no lie
a bird stopped by
at this Bay beat

*Original song from **"Friday Night Jazzz"***
by Rainer Neumann

Harpo "the Mensch"

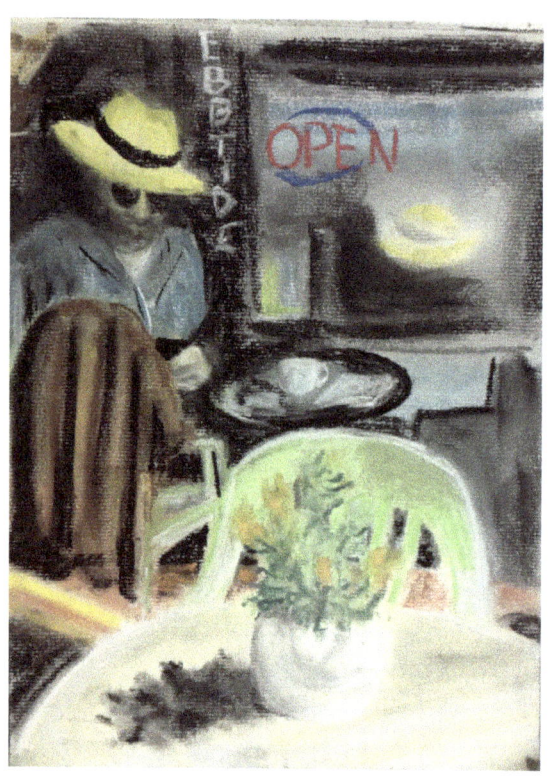

What to say...
I could write in details
of the moments of hellos and
"could you fix the chairs on the deck?"
or I could write of more pronounced "notions"
offered by this man who found his place
and gatherings in HMB...
opening the Cafe Society and the
venerable Ebbtide Cafe
and filling them with baristas brewing
good cheer...

I could write of the Friday Night jazz groups
and the sounds that reminded him of Dusseldorf
or the poetry nights that brought the
wordsmiths out of the coast and
the corners of the community...

One day he noticed my Rilke on the table
and that I was translating my father's poetry
he helped me with a verse I was struggling with
and noticed my pastel drawings...
from this came an exhibit at the Cafe Society
of pastels I had drawn over many years
traveling on the coast from Pigeon Point to Point Reyes
he opened the door to a creative time in my life...

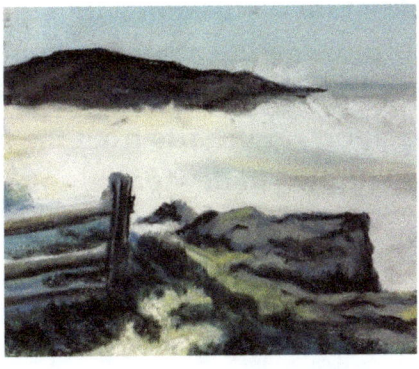

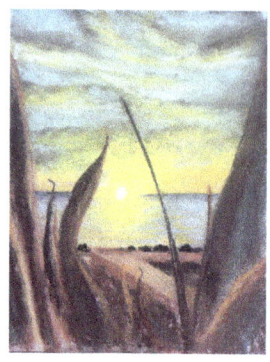

I could write of the hours
spent on the deck of the Ebbtide Cafe
listening to the sound of breaking waves
and the Sunday sound of applause
heard for the incredible jazz musicians
coming from afar
filling the air with their improvisational solos
searching and reaching and eventually uniting
and settling in the nearby waves...
while Harpo and crew catered to all the anticipating visitors...

some of us settled into the inside chairs
of the cafe with free coffee for our
weekly film discussion with random
habitués coming at all open hours
conversation was paramount for Harpo
and his support for the arts from the mandalas
exhibited to new pastels of a
transcendent coast

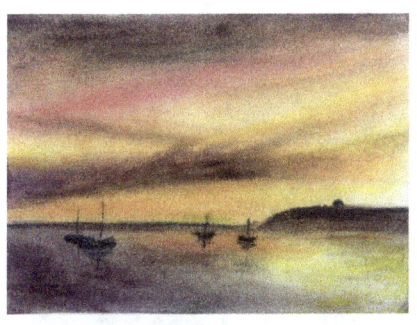

His support for my poetic attempts
became a book of poems and songs that emerged out of those
jazzzy Friday Nights
with Marty and Steve and all the incredible
musicians that graced his cafe society…

I could write of his generosity and what
he brought to the community...
as I think of him and what he offered
and who he touched in his daily "being there"
and his outreach to all who passed by...
and those who stayed a while
who will never forget him…

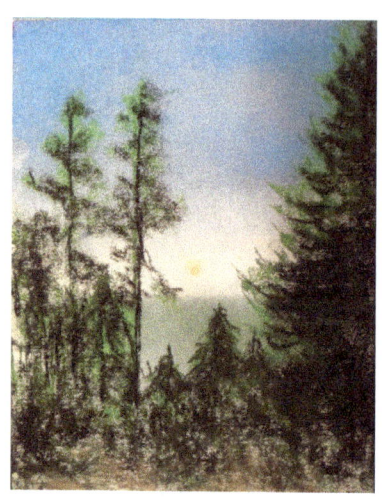

Every Year at this Time

Every year at this time
the solstice comes again
letting go of darkness
to let the light descend

Light in all its streaming
comes into every home
and travels every pathway
that our hearts have known

In this cosmic turning
in stillness so profound
can we still find wonder
in all that is earthbound

*(translated and rewritten
from a German Christmas song
words by Eduard Ebel to an older folk melody)*

On Winter's Tree

on winter's tree
the candles brighten
a festive mood
of love and peace
as if to say:
you see in me
the light of hope
in silence felt

the children gaze
in bright amazement
their eyes do laugh
with joyful hearts
the time is filled
with such enchantment
the old look up
to stars above

the candle light
brightens the home
the heart does feel
its presence there
to bless the food
on the festive table
remembering
the giving earth

blessed are
the older people
blessed too
the growing child
today the light
brings comfort to you
to black and brown
and white haired too

to all good people
who love each other
you will receive
good tidings too
and if you stay
true and peaceful
light will enter
your home again

no ears could hear
the words they felt
nor eyes could see
the unseeable

the tree was bright
with such a glow
the living light
had come again

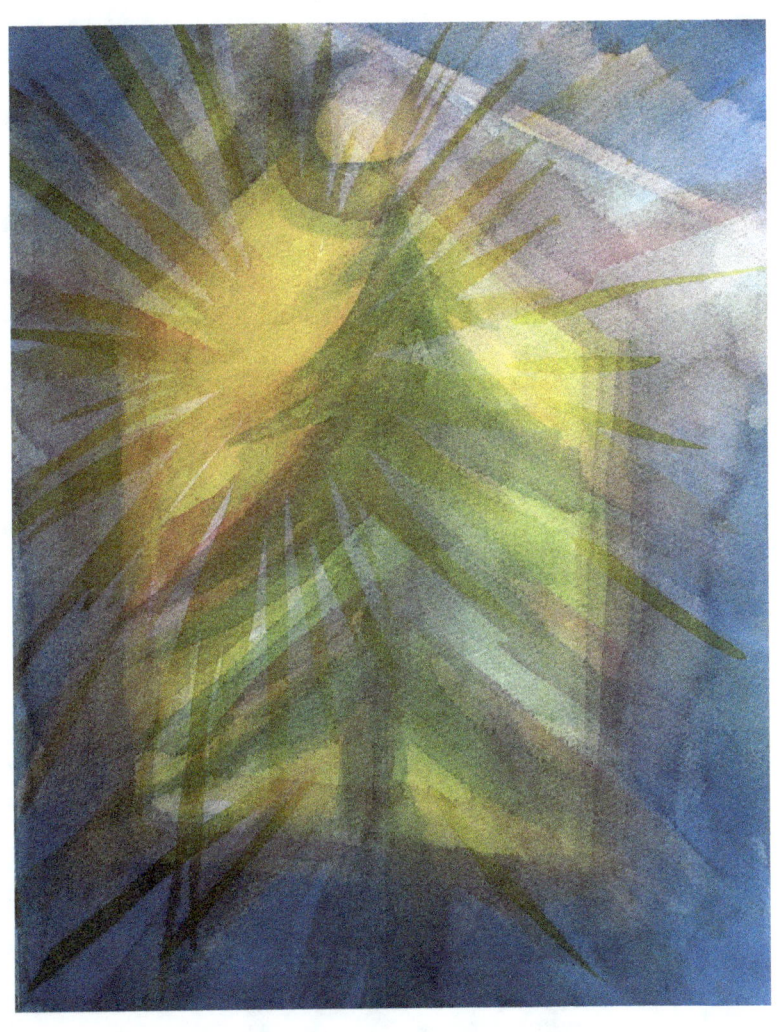

*(translated and rewritten
from a German Christmas song
by Hermann Kletke.*

Softly Whispers the Snow

softly whispers the snow
still and calm rests the sea
star light brightens the path
joy to all the time is near

comfort enters the heart
still is sadness and grief
sorrows of life now depart
joy to all the time is near

soon is the darkest of nights
a chorus of voices sing out
listen how lovely they sound
joy to all the time is near

*(translated and rewritten
from a German Christmas song
words by Eduard Ebel
to an older folk melody)*

*Solstice versions of all songs
by Rainer Neumann © 2022)*

afterward

At this time twenty one cards are available as a compilation to be hung on a string with or without the driftwood or any number of cards can be individually procured . There is no limited edition. The book will be available at: lulu.com/spotlight/rneumann and cards and driftwood are available at: onhighwayone@gmail.com

A display of Poetry and Pastels on a string
at the Half Moon Bay Coffee Company

hopes and dreams

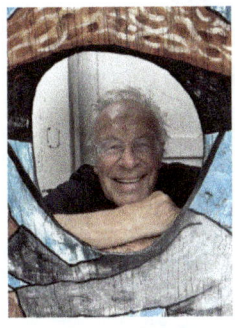

to create
through the extensions of
our lives and arts

to imagine
out of our living circumstances
what is possible

to fulfill our capacities
as human beings
from compassion to action

to comprehend
the natural world we have inherited
and the universe we are a part of

to embrace
the ultimate aspects
of our humanity

to resonate
on the vibrational levels
of all existence

to continue
coming closer to the ok above

Rainer

Other Works of Interest

Wandering in Coyoacán
(a book of prose poems and pastel drawings of Mexico)
intersections of concern
(a book of poetry and images)
Friday Night Jazzz
(poems songs and images)
Our Time Has Just Begun
(book of lyrics and images)
from Pigeon Point to Point Reyes
(book of pastel drawings and haikus)
Masama
(a tale of discovery)
Labyrinth a mythic journey
(two brothers define their lives)
Goodbye Bolinas we'll see you again
(A paean to the summer of love)
On the Wings of a Swan
(An allegory of love and war)
How To Find A Job
(a rhythmic journey)
Path and Goal
(the poetry of Alfred Neumann)
I am always with you
(a journal by Marianne Neumann)
both books translated by the author

Available through:
lulu.com/spotlight/rneumann
For further inquiries email:
onhighwayone@gmail.com

www.ingramcontent.com/pod-product-compliance
Lightning Source LLC
Chambersburg PA
CBHW072221170526
45158CB00002BA/699